This journal belongs to:

Because He Lives

Because He Lives

A Devotional Journal
for Easter

Jennifer Flanders

PRESCOTT PUBLISHING
Tyler, Texas

BECAUSE HE LIVES: A DEVOTIONAL JOURNAL FOR EASTER
Copyright ©2018 by Jennifer Flanders. www.flandersfamily.info

The vast majority of clip art in this book is from a set of 9 CDs my husband bought me back in 1996 called Masterclips 101,000 Premium Images Collection. This was long before I started blogging or writing or publishing anything, and I hadn't the foggiest idea what I'd ever do with such a thing — but I held onto it, just in case, and now I use it all the time!

Additional images (and permission to use them in this publication) were obtained by purchasing a premium membership to The Graphics Fairy (members.thegraphicsfairy.com). I found a wealth of public domain images (including dozens of beautifully intricate religious line art drawings) at openclipart.org, olddesignshop.com, freevintageart.com, www.creationism.org/images/DoreBible Illus/index.htm, and (especially) www.marysrosaries.com/collaboration/index.php?title=Category: Black_and_White_Religious_Pictures.

ISBN: 978-1-938945-36-6

Dedication

To my risen Lord & Savior,
Jesus Christ,
who paid the penalty
for all my sin

Contents

Introduction

This book belongs to you. There is no right or wrong way to complete it. You may use these pages to record thoughts, compose poetry, set goals, write prayers, paste photographs, paint pictures, draw sketches, make lists, tape mementos— or a combination of any or all of the above.

My goal in creating this little journal is to inspire you to think deeply about the unfathomable grace and mercy of the Lord Jesus Christ. His love for us compelled Him to take on flesh and come to earth, where He lived a perfect life, then paid the penalty for our sins by dying on a cruel cross in our place.

This book is a celebration of His life, death, burial, and resurrection. When Jesus rose from the grave, He conquered sin and death forevermore. Because He lives, forgiveness and eternal life can be ours by grace through faith in Him alone. He has given us hope and a future.

As you work your way through these pages and you consider the unsurpassing riches of His grace, I pray your heart will sing with mine, "Hallelujah! What a Savior!"

Soli Deo Gloria,
Jennifer Flanders

Because He Lives
by Kristin Chenoweth

God sent His son, they called Him Jesus;
He came to love, heal and forgive.
He lived and died to buy my pardon.
An empty grave is there to
prove my Savior lives.

How sweet to hold a newborn baby
And feel the pride and joy He gives,
But greater still the calm assurance
This child can face uncertain days,
because He lives!

And then one day, I'll cross the river;
I'll fight life's final war with pain
And then, as death gives way to victory,
I'll see the lights of glory and
I'll know He lives.

Because He lives, I can face tomorrow.
Because He lives, all fear is gone.
Because I know He holds the future,
And life is worth the living,
just because He lives!

Christ's Coming Foretold

Born of a Virgin

"Therefore the Lord himself shall give you a sign; Behold, a virgin shall conceive, and bear a Son, and shall call His name Immanuel."

- Isaiah 7:14, KJV

The Only Begotten of the Father

"I will surely tell of the decree of the LORD: He said to Me, 'You are My Son, Today I have begotten You.'"

- Psalm 2:7, NASB

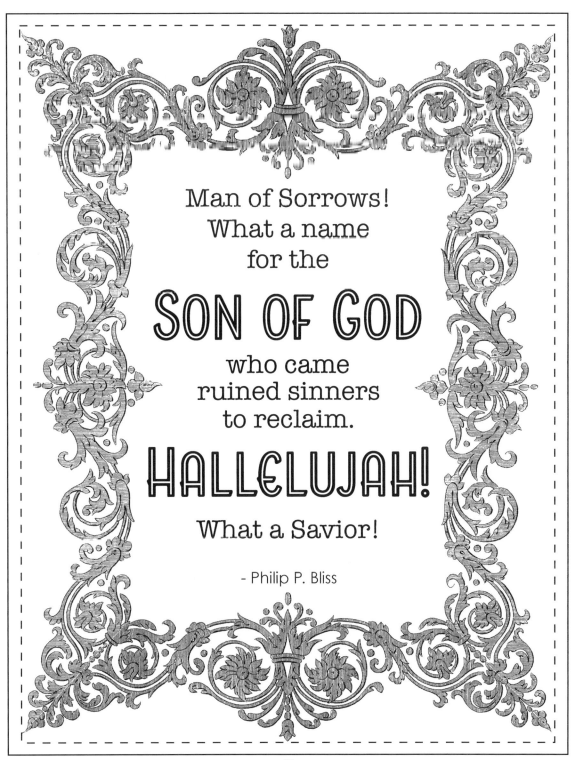

Man of Sorrows!
What a name
for the

SON OF GOD

who came
ruined sinners
to reclaim.

HALLELUJAH!

What a Savior!

- Philip P. Bliss

King of Kings

"You said, "I have made a covenant with my chosen one,
I have sworn to David my servant, I will establish your line forever
and make your throne firm through all generations.'"

- Psalm 89:3-4, NIV

Prince of Peace

"And He will be called Wonderful
Counselor, Mighty God, Everlasting
Father, Prince of Peace."

- Isaiah 9:6, NIV

The Long Awaited Messiah

Genesis
3:15

Genesis
22:8

Isaiah
7:14

Isaiah
9:6-7

Micah
5:2

Malachi
3:1

Precious Redeemer

"As for me, I know that my Redeemer lives,
And at the last He will take His stand on the earth."

- Job 19:25, NASB

Only Begotten
of the Father

"But when the fullness of time had come,
God sent forth his Son, born of woman,
born under the law..."

- Galatians 4:4, ESV

Firstborn
among Many Brethren

"...to redeem those under the law, that we
might receive adoption to sonship."

- Galatians 4:5, NIV

"We have found Him of whom Moses in the Law and also
the Prophets wrote — Jesus of Nazareth, the son of Joseph."

- John 1:45, NASB

In the Fulness of Time

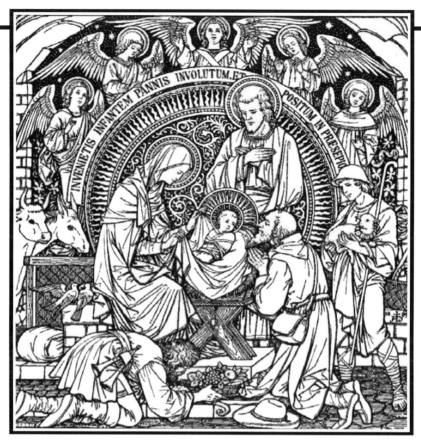

Born in a Stable

"And she brought forth her firstborn Son, and wrapped Him
in swaddling clothes, and laid Him in a manger;
because there was no room for them in the inn."

- Luke 2:7, KJV

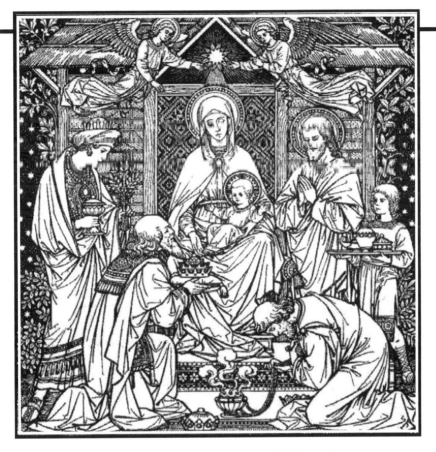

Worshiped by Magi

"Where is He that is born King of the Jews? for we have
seen His star in the east, and are come to worship Him."

- Matthew 2:2, KJV

God
with
Us

"Behold, the virgin shall conceive and bear a Son,
and they shall call His name Immanuel
(which means, God with us)."

- Matthew 1:23, ESV

Christ and the Father are One

John
1:1-2

John
10:29-30

John
17:21

John
14:9-11

"Mary kept all these things & pondered them in her heart."

- Luke 2:19, KJV

"Thanks *be* unto God for His unspeakable gift."

- 2 Corinthians 9:15, KJV

- Isaiah 52:7

- Luke 2:10

- Luke 8:1

- Acts 10:36

Praise the Lord

"My mouth will speak in praise of the LORD.
Let every creature praise His holy name for ever and ever."

- Psalm 145:21, NIV

Glory
to
God

"Glory to God in the highest,
and on earth peace,
good will toward men."

- Luke 2:14, KJV

"Truly I say to you, until heaven and earth pass away, not the smallest letter or stroke shall pass from the Law until all is accomplished."

- Matthew 5:18, NASB

He Took On Flesh

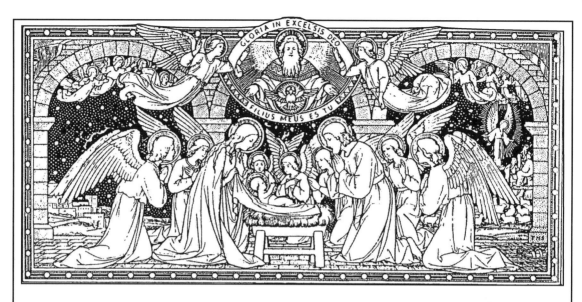

He Left the Splendor of Heaven

"For you know the grace of our Lord Jesus Christ, that though
He was rich, yet for your sakes He became poor,
so that you through His poverty might become rich."

- 2 Corinthians 8:9, NIV

"And the Word was made flesh, and dwelt among us, and we beheld His glory, the glory as of the only Begotten of the Father, full of grace and truth."

-John 1:14 KJV

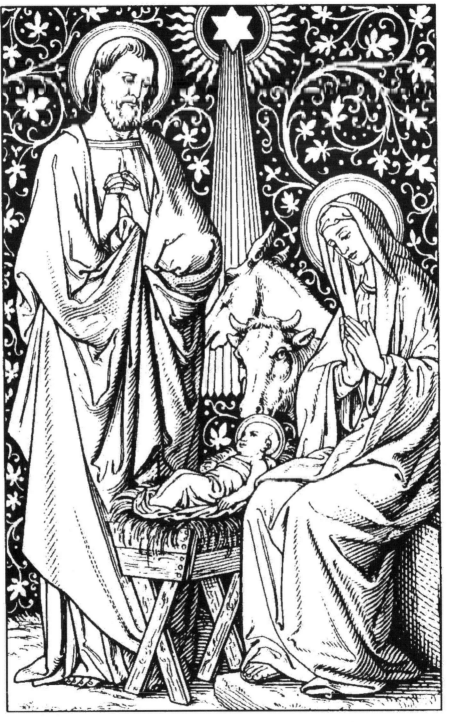

God Incarnate

"Have this attitude in yourselves which was also in Christ Jesus, who, although He existed in the form of God, did not regard equality with God a thing to be grasped..."

- Philippians 2:5, NASB

Born to Die

"...but emptied Himself, taking the form of a
bond-servant, *and*... humbled Himself by
becoming obedient to the point of death,
even death on a cross."

- Philippians 2:7, NASB

H
- Philip. 2:3 -

U
- Matt. 23:12 -

M
- James 4:6 -

I
- 2 Chron. 7:14 -

- 1 Peter 5:6 -

- Isaiah 2:11 -

- Psalm 25:9 -

- James 4:10 -

Hark, the Herald Angels Sing!

"There were in the same country shepherds abiding in the field,
keeping watch over their flock by night. And, lo,
the angel of the Lord came upon them, and the glory of the Lord
shone round about them: and they were sore afraid."

- Luke 2:8-9, KJV

Glory to the Newborn King!

"And the angel said unto them, Fear not: for, behold,
I bring you good tidings of great joy,
which shall be to all people. For unto you is born this day
in the city of David a Saviour, which is Christ the Lord."

- Luke 2:10-11, KJV

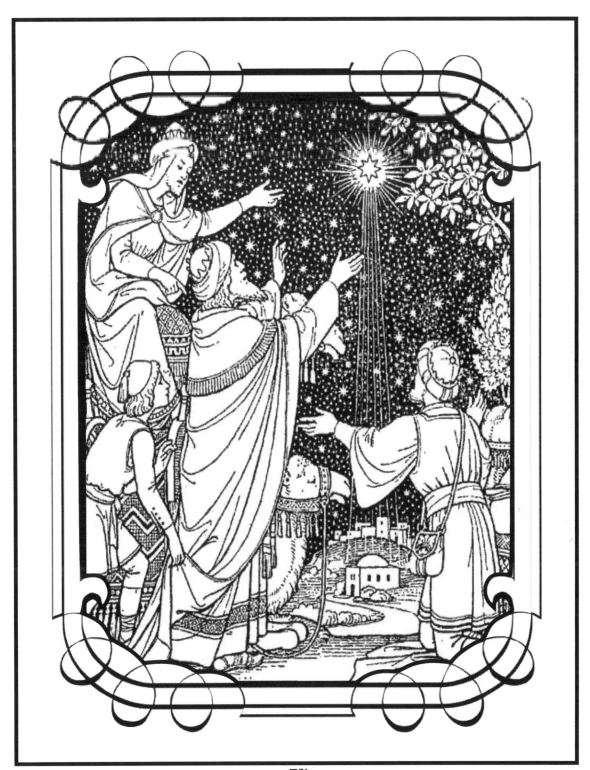

"The fear of the LORD is the beginning of wisdom; all who follow
His precepts have good understanding. To Him belongs eternal praise."

- Psalm 111:10, NIV

The Living Word

Eternal Word

"In the beginning was the Word, and the Word was with God, and the Word was God. He was with God in the beginning."

- John 1:1-2, NIV

Creative Word

"All things were
created by Him,
and apart from him
not one thing was
created that
has been created."

- John 1:3, NET

JESUS GREW IN WISDOM, IN STATURE, AND IN FAVOR WITH GOD AND MAN.

- Luke 2:52, NIV -

About My Father's Business

"Everyone who heard Him was amazed by
His understanding and His answers."

- Luke 2:47, NIV

Word of Life

"In Him was life, and that life was the light of all mankind."

- John 1:4, NIV

Light of the World

"The light shines in the darkness,
and the darkness has not overcome it."

- John 1:5

We Hope in Him

"For everything that was written in the past
was written for our instruction, so that through
endurance and the encouragement of the Scriptures,
we might have hope."

- Romans 15:4, NASB

Holy & Incorruptible

"For you have been born again,
not of perishable seed,
but of imperishable, through the
living and enduring word of God."

- 1 Peter 1:23, NIV

God is at Work

"And we also thank God continually because,
when you received the word of God, which you heard from us,
you accepted it not as a human word, but as it actually is,
the word of God, which is indeed at work in you who believe."

- 1 Thessalonians 2:13, NIV

"All Scripture is inspired by God and profitable for teaching,
for reproof, for correction, for training in righteousness."

- 2 Timothy 3:16, NASB

Miracle of Miracles

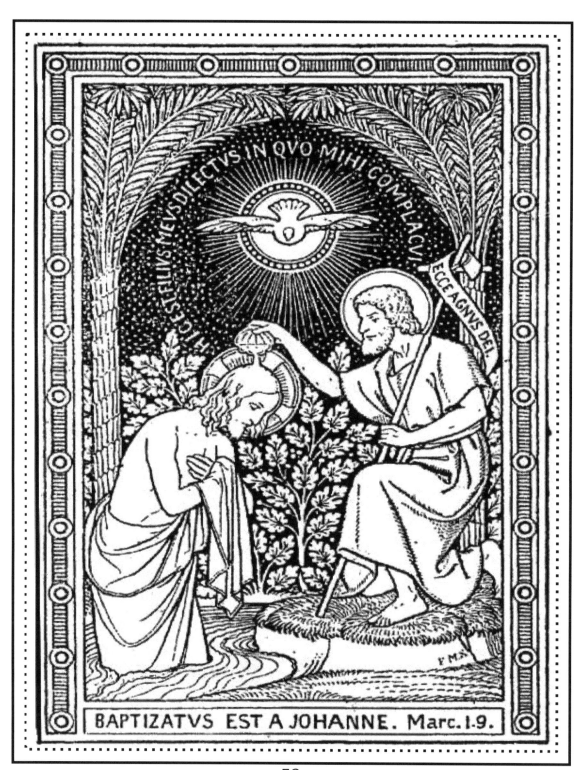

ECCE AGNVS DEI

TV ES FILIVS MEVS DILECTVS IN QVO MIHI COMPLACV

BAPTIZATVS EST A JOHANNE. Marc. 1·9.

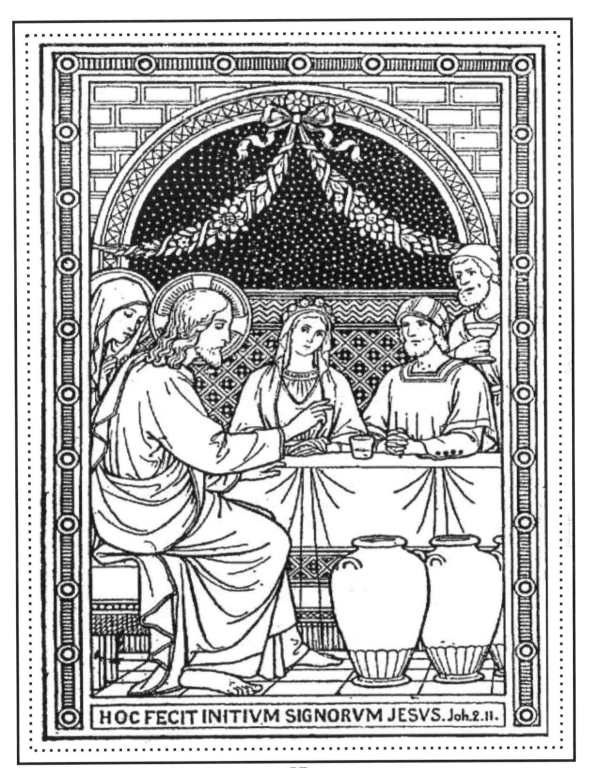

HOC FECIT INITIVM SIGNORVM JESVS. Joh.2.11.

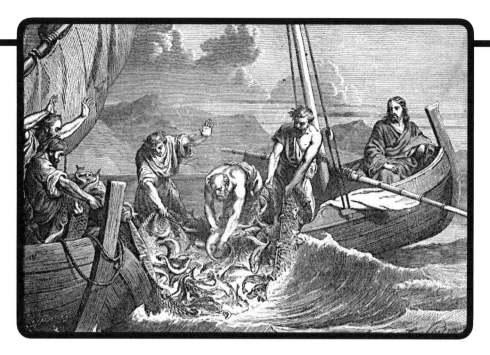

Haven't You Any Fish?

"He said, 'Throw your net on the right side of the boat…'
When they did, they were unable to haul the net in
because of the large number of fish."

- John 21:6, NIV

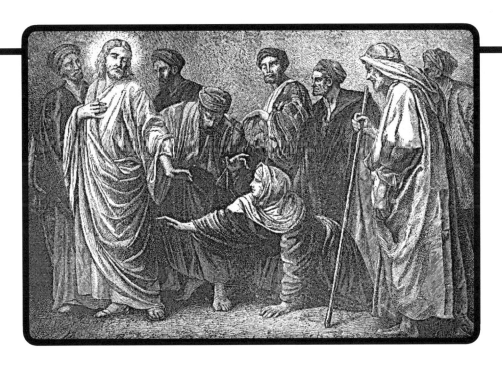

Who Touched Me?

"A woman who had a hemorrhage for twelve years & could not be healed by anyone, came up behind Him & touched the fringe of His cloak & immediately her hemorrhage stopped."

- Luke 8:43-44, NASB

Your Faith has Healed You

"A man with leprosy came to Him and begged Him on his knees, 'If You are willing, You can make me clean.' ...He reached out His hand and touched the man. 'I am willing,' He said. 'Be clean!'"

- Mark 1:40-41, NIV

Water
He turned
into wine;
Healed the lame,
the sick, the blind;

RAISED THE DEAD

with
pow'r divine!

HALLELUJAH!

What a Savior.

- Jennifer Flanders

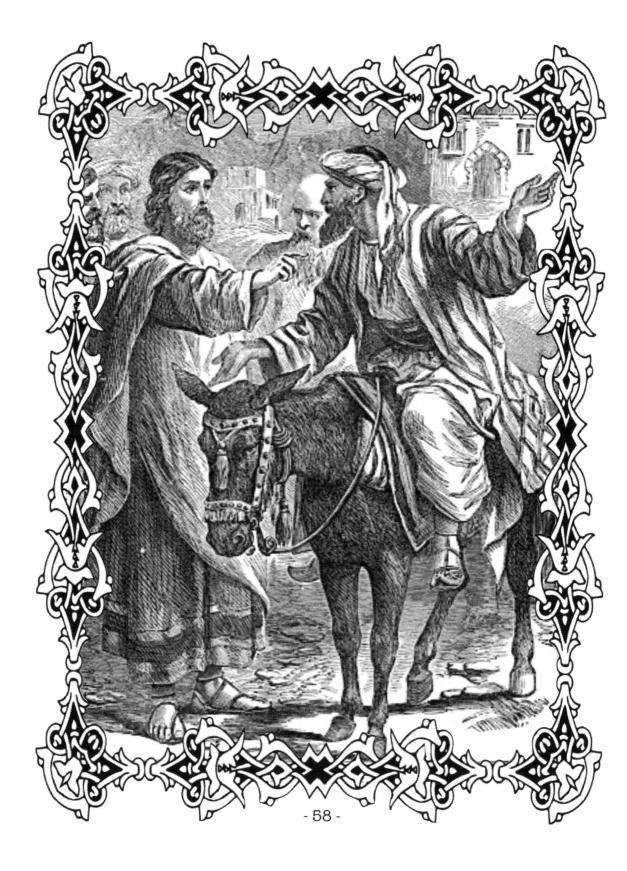

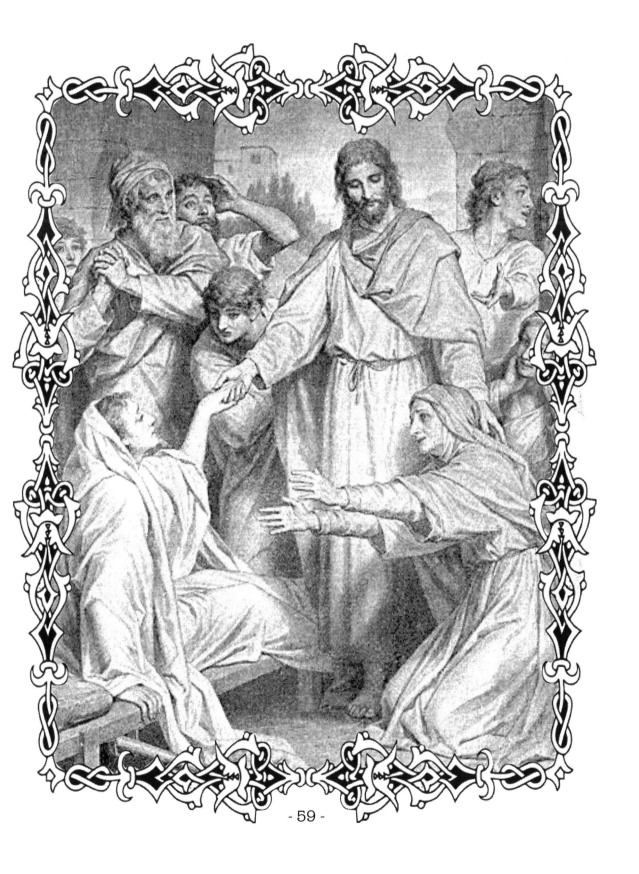

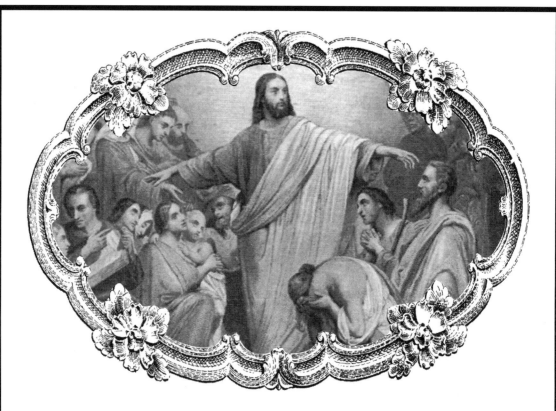

The Great Physician

"On hearing this, Jesus said to them,
'It is not the healthy who need a doctor, but the sick.
I have not come to call the righteous, but sinners.'"

- Mark 2:17, NIV

The God Who Heals

"People soon began bringing to Him all who were sick.
And whatever their sickness or disease, or if they were demon
possessed or epileptic or paralyzed—He healed them all."

- Matthew 4:24, NLT

"As for me, I said: "O LORD, have mercy on me!
Heal me, for I have sinned against You! "

- Psalm 41:4, NET

Love
Divine

- John 13:34-35

- Luke 6:27, 31-35

- 1 John 4:7-12

- 1 Corinthians 13:4-8

"I will sing of the lovingkindness of the LORD forever;
To all generations I will make known
Your faithfulness with my mouth."

- Psalm 89:1, NASB

Behold what manner of Love the Father given unto us...

1 John 3:1

Walk in Love

"And walk in love, as Christ loved us
and gave himself up for us,
a fragrant offering and sacrifice to God."

- Ephesians 5:2, ESV

Love from a Pure Heart

"You have purified your souls by obeying the truth
in order to show sincere mutual love.
So love one another earnestly from a pure heart."

- 1 Peter 1:22, NET

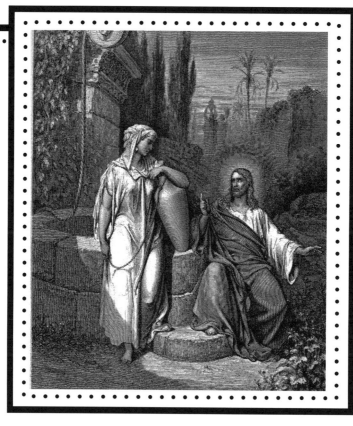

He Provides Abundantly

"Jesus answered, 'Everyone who drinks this water will be thirsty
again, but whoever drinks the water I give them will never thirst.
Indeed, the water I give them will become in them
a spring of water welling up to eternal life."

- John 4:13-14, NIV

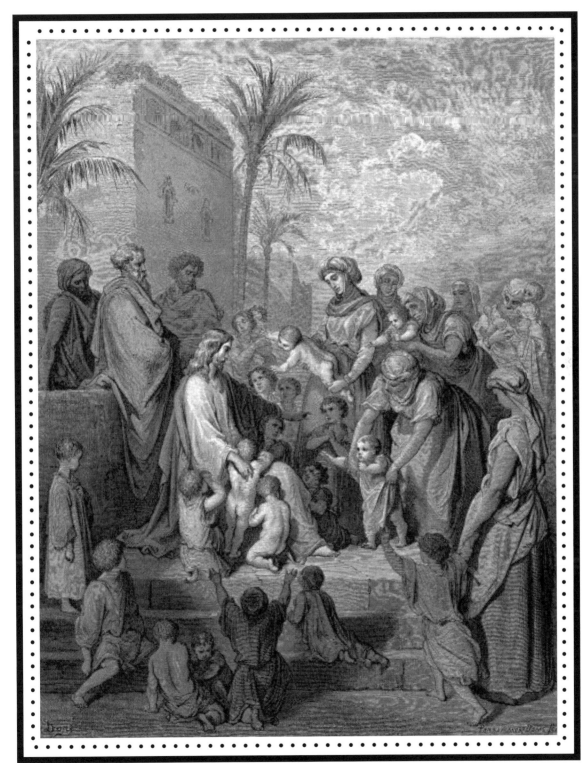

I am My Beloved's

"He has brought me to his banquet hall,
And his banner over me is love."

- Song of Solomon 2:4, NASB

My Beloved is Mine

"I will show my love to the one I called 'Not my loved one.'
I will say to those called 'Not my people,' 'You are my people';
and they will say, 'You are my God.'"

- Hosea 2:23, NIV

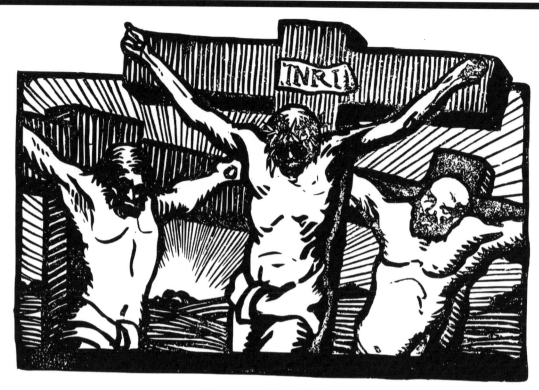

Born to Die

"For the Son of Man must die,
as the Scriptures declared long ago."

- Mark 14:21, NLT

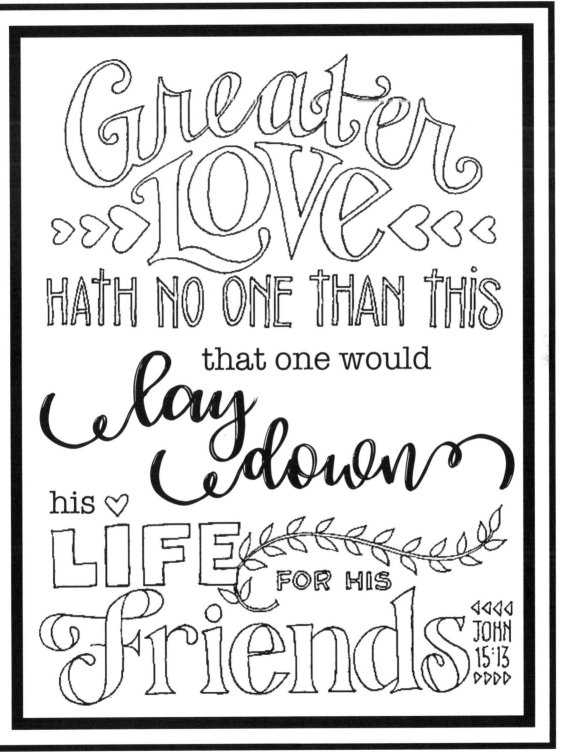

"In Him we have redemption through His blood,
the forgiveness of our trespasses,
according to the riches of His grace that He lavished upon us."

- Ephesians 1:7-8, NASB

Hosanna in
the Highest

BLESSED
IS HE WHO
COMES
IN THE
NAME OF
THE LORD!

- John 12:13, NIV

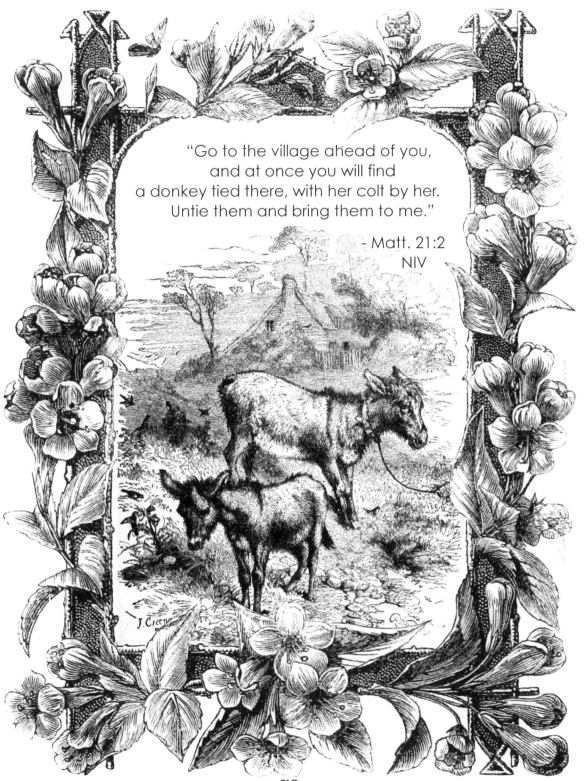

"Go to the village ahead of you,
and at once you will find
a donkey tied there, with her colt by her.
Untie them and bring them to me."

- Matt. 21:2
NIV

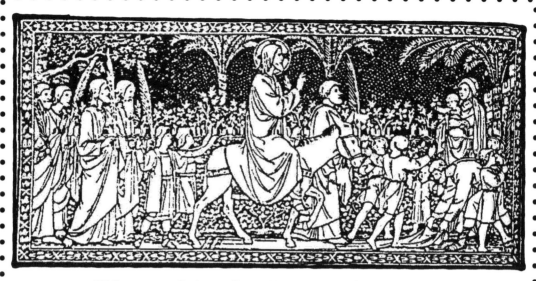

Blessed is the King of Israel!

"Do not be afraid, O daughter of Zion.
See, your King is coming, seated on the colt of a donkey."

- John 12:15, Berean Study Bible

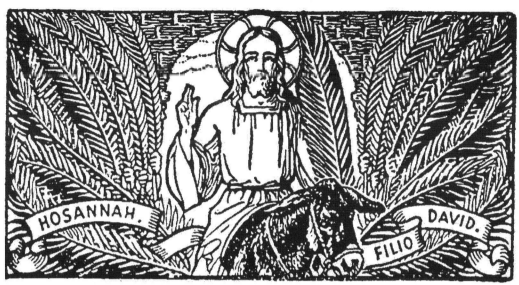

Hosanna to the son of David!

"They took palm branches
and went out to meet him, shouting, 'Hosanna!'"

- John 12:13, NIV

Rejoice Greatly!

"Rejoice, O people of Zion!
Shout in triumph, O people of Jerusalem! "

- Zechariah 9:9a, NLT

Behold Your King

"Look, your king is coming to you. He is righteous and victorious,
yet he is humble, riding on a donkey"

- Zechariah 9:9b, NLT

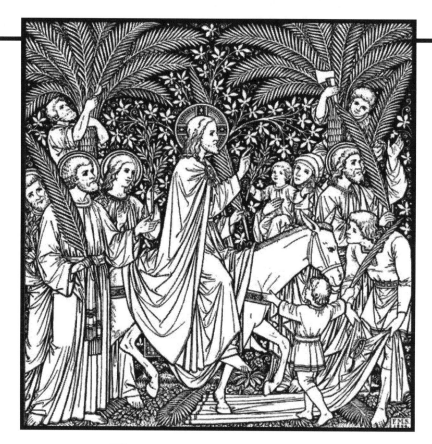

Shout in Triumph

"Yes, the LORD is for me; He will help me.
I will look in triumph at those who hate me."

- Psalm 118:7, NLT

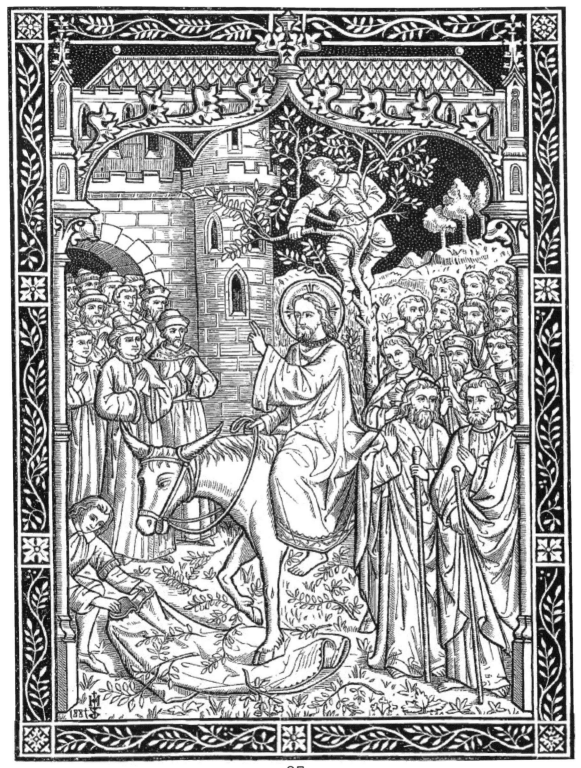

Enter His Gates

"Open for me the gates where the righteous enter,
and I will go in and thank the LORD."

- Psalm 118:19, NLT

Bless His Name

"Enter His gates with thanksgiving and His courts with praise.
Give thanks to Him, bless His name."

- Psalm 100:4, NASB

"Open the gates that the righteous nation may enter,
the nation that keeps faith."

- Isaiah 26:2, NIV

The Passion Week

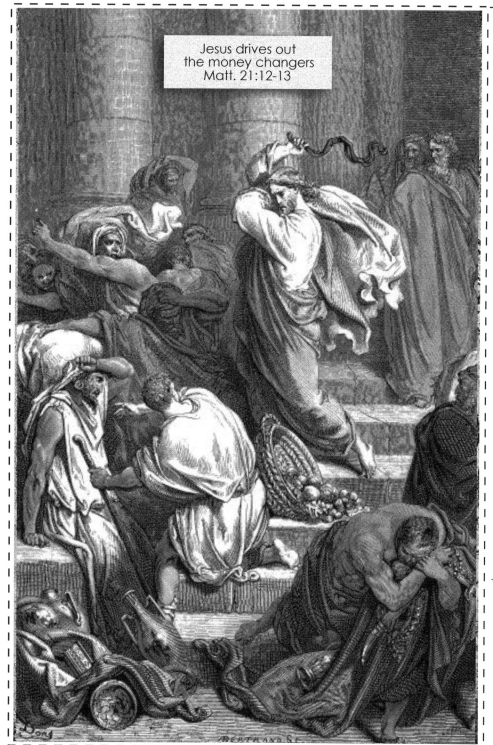

Jesus drives out
the money changers
Matt. 21:12-13

To those selling doves He said, "Get these out of here! How dare you turn My Father's house into a marketplace!"

His disciples remembered it is written, "Zeal for Your house will consume Me."

- John 2: 16-17

Passion Week: Who Said What?

_____ 1. "I find no guilt in this man." (Luke 23:4)

_____ 2. "Blessed is He who comes in the name of the Lord! Hosanna in the highest!" (Matthew 21:9)

_____ 3. "Father, forgive them, for they know not what they do." (Luke 23:34)

_____ 4. "Remember me when you come into your kingdom." (Luke 23:42)

_____ 5. "It is better for you that one man die for the people than that the whole nation perish." (John 11:49)

_____ 6. "Why seek you the living among the dead?" (Luke 24:5)

_____ 7. "Even if I have to die with you, I will not deny You" (Matthew 26:33)

_____ 8. "Crucify Him! Crucify Him!" (Luke 23:21)

_____ 9. "Surely this was the son of God." (Matthew 27:54)

_____ 10. "He has uttered blasphemy. What further witnesses do we need?" (Matthew 26:65)

_____ 11. "I have sinned by betraying innocent blood." (Matthew 27:4)

_____ 12. "Have nothing to do with that righteous man, for I hewave suffered much because of him today in a dream." (Matthew 27:19)

_____ 13. "This is Jesus, the King of the Jews." (Matthew 27:37)

_____ 14. "Order the tomb to be made secure until the third day, lest his disciples go and steal him away." (Matthew 27:63-64)

_____ 15. "Wait, let us see whether Elijah will come to take him down." (Mark 15:36)

_____ 16. "Who will roll away the stone for us from the entrance of the tomb?" (Mark 16:3)

_____ 17. "If you are the King of the Jews, save yourself!" (Luke 23:36-37)

_____ 18. "Are you the only visitor to Jerusalem who does not know the things that have happened there in these days?" (Luke 24:18)

_____ 19. "Peace to you!" (Luke 24:36)

_____ 20. "Unless I see in his hands the mark of the nails, and place my finger into the mark of the nails, and place my hand into his side, I will never believe." (John 20:25)

a. witnesses at the crucifixion

b. the resurrected Jesus

c. Mary Magdalene

d. the thief on the cross

e. the soldiers at the crucifixion

f. the Centurion

g. Pilate

h. the angel at the tomb

i. the Jews at Jesus trial

j. Judas Iscariot

k. the High Priest

l. Peter

m. Cleopas, speaking to Jesus

n. the Pharisees

o. Jesus on the cross

p. Pilate's wife

q. Thomas

r. the sign over Jesus's cross

s. the crowd outside Jerusalem

t. Caiaphas

(answer key on p. 210)

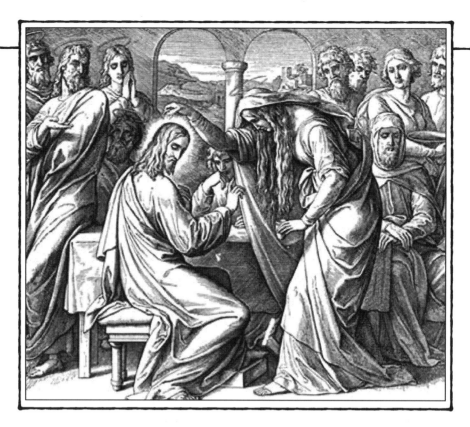

Annointing Oil

"For when she poured this perfume on My body,
she did it to prepare Me for burial. Truly I say to you, wherever this
gospel is preached in the whole world, what this woman has done
will also be spoken of in memory of her."

- Matthew 26:12-13, NASB

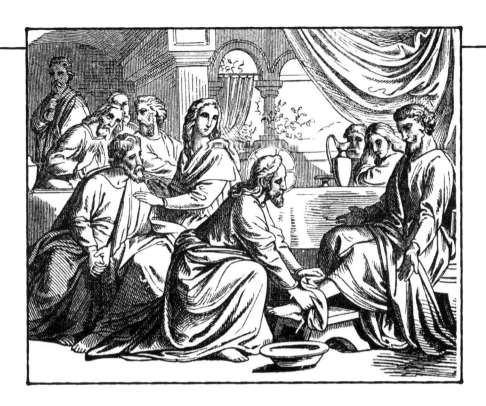

Foot Washing

"Peter said to Him, 'Never shall You wash my feet!'
Jesus answered him, 'If I do not wash you, you have no part with Me.'"

- John 13:8, NASB

Just as the
Son of Man
did not come to be served,
but to serve,
and to
give His life
as a ransom
for many.

- Matthew 20:28
NIV

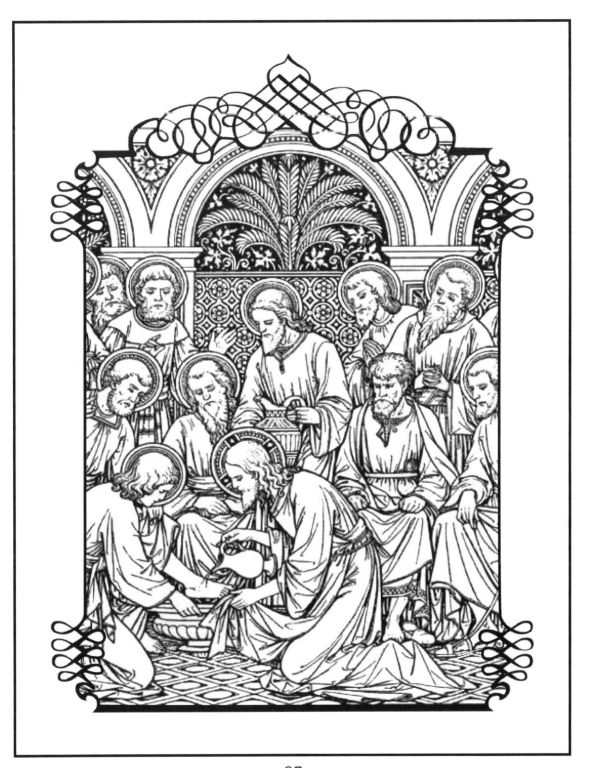

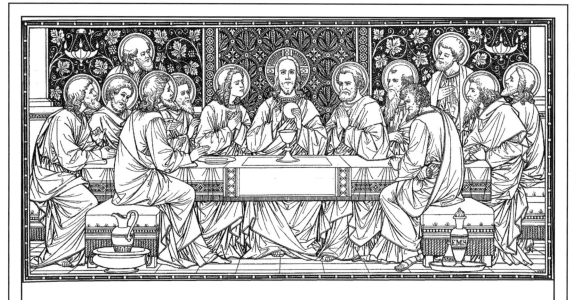

Breaking Bread

"And when He had given thanks, He broke it, and said,
Take, eat: this is My body, which is broken for you:
this do in remembrance of Me."

- 1 Corinthians 11:24, NKJV

The Lord's Supper

- Matthew
26:17-30

- Mark
14:12-26

- Luke
22:7-23

- John
13:15-30

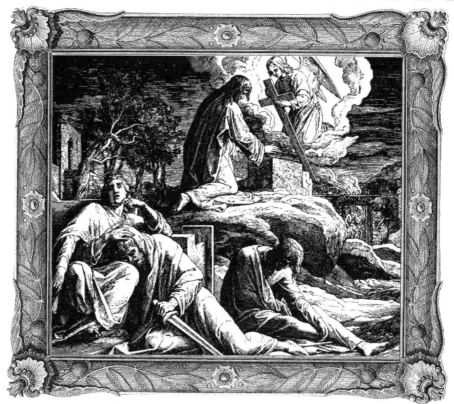

Interceding for Us

"He knelt down and began to pray, saying,
'Father, if You are willing, remove this cup from Me; yet not My will,
but Yours be done.' Now an angel from heaven appeared to Him,
strengthening Him."

- Luke 22:41-43, NASB

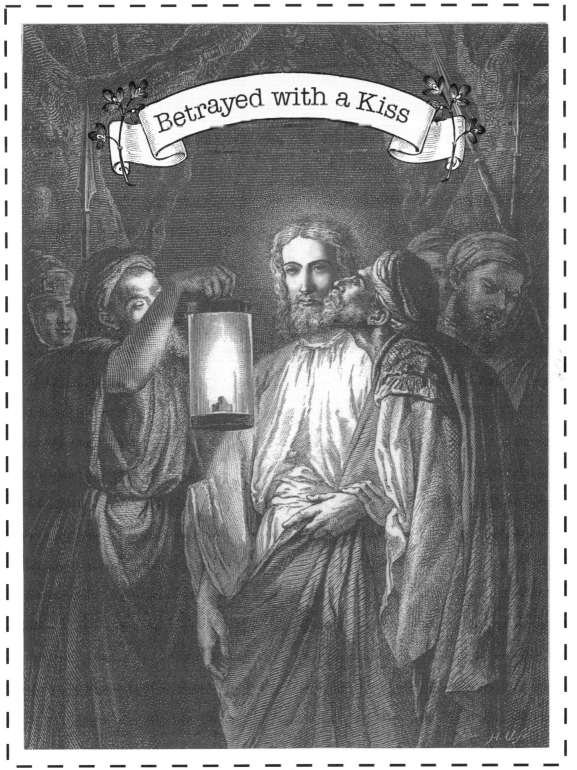

Betrayed with a Kiss

"When He rose from prayer, He came to the disciples and found them
sleeping from sorrow, and said to them, 'Why are you sleeping?
Get up and pray that you may not enter into temptation.'"

- Luke 22:45-46, NASB

Spotless
Lamb of God

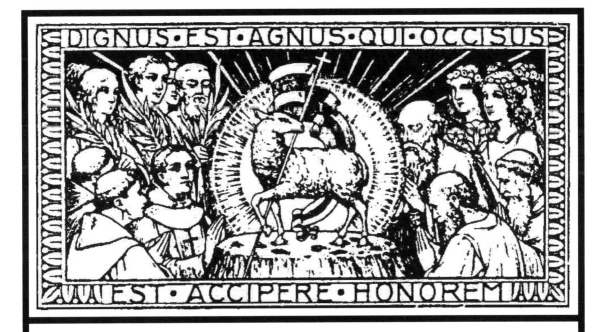

Guilty, vile, and helpless we;
spotless

LAMB OF GOD

was He;
"Full atonement!"
Can it be?

HALLELUJAH!

What a Savior!

- Philip P. Bliss

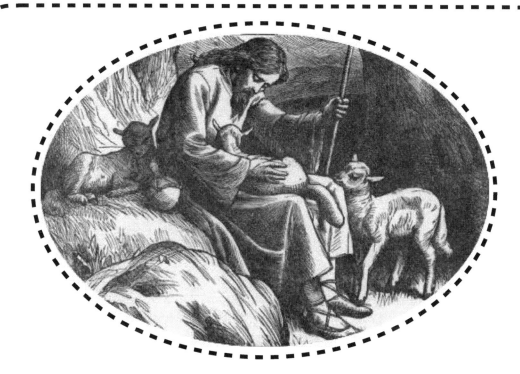

God Provides

"And Abraham said, My son, God will provide Himself a lamb for a burnt offering: so they went both of them together."

- Genesis 22:8, KJV

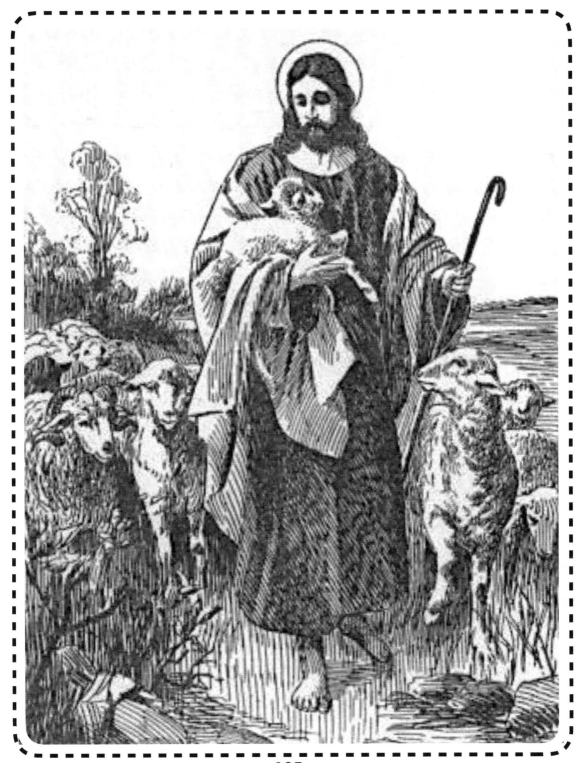

By His Blood

"It was not with perishable things
such as silver or gold
that you were redeemed..."

- 1 Peter 1:18, NIV

I am Redeemed

"...but with the
precious blood of Christ, a lamb
without blemish or defect."

- 1 Peter 1:19, NIV

No Fault in this Man

"I have examined Him in your presence and have found
no basis for your charges against Him…
He has done nothing to deserve death."

- Luke 23:14-15, NIV

Away with Him!

"Wanting to release Jesus, Pilate appealed to them again. But they kept shouting, 'Crucify him! Crucify him!'"

- Luke 23:20-21, NIV

The Lion of Judah

"Do not weep! See, the Lion of the tribe of Judah,
the Root of David, has triumphed."

- Revelation 5:5, NIV

Our Sacrificial Lamb

"Behold, the Lamb of God
who takes away the sin of the world!"

- John 1:29, NASB

And he looked at Jesus
as he walked by and said,

"Behold, the
Lamb of God!"

- John 1:36
NKJV

Without Blemish or Spot

- Acts
8:32-35

- 1 Corinthians
5:7

- 1 Peter
3:18

- Matthew
26:19, 26-29

- Revelation
7:16-17

"...He was led like a lamb to the slaughter, and
as a sheep before its shearers is silent, so He did not open His mouth."

- Isaiah 53:7, NIV

Mocked
and Scorned

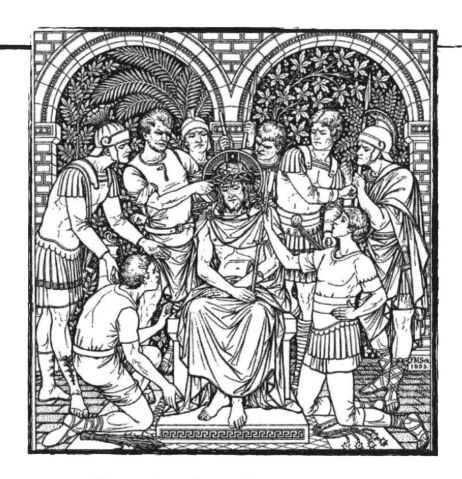

Despised and Rejected

"But with loud shouts they insistently demanded
that He be crucified, and their shouts prevailed."

- Luke 23:23, NIV

Bearing shame
and scoffing rude,

IN MY PLACE

CONDEMNED

He stood;
Sealed my pardon with His blood.

HALLELUJAH!

What a Savior!

- Philip P. Bliss

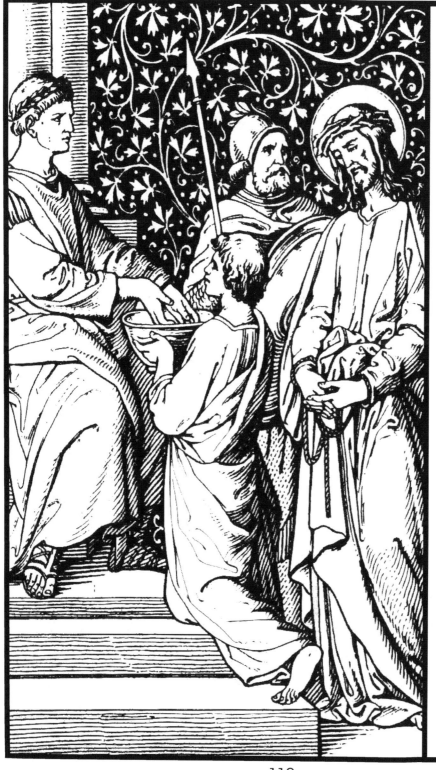

"Then said Pilate to the chief priests and to the people, I find no fault in this man."

Luke 23:4
KJV

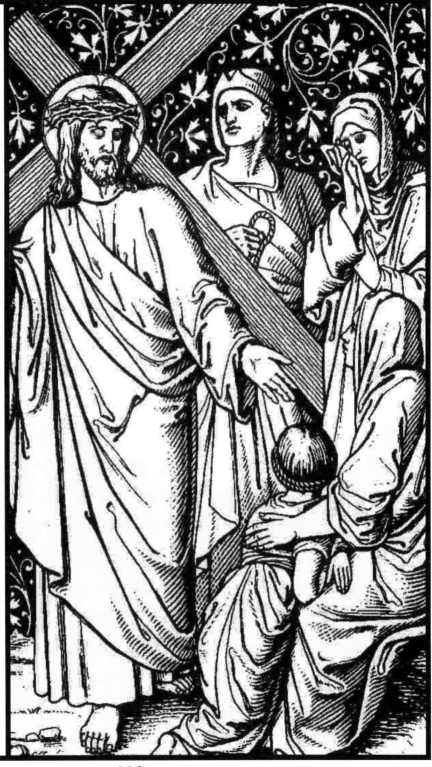

"Surely He hath borne our griefs and carried our sorrows... and the Lord has laid on Him the iniquity of us all."

Isaiah 53: 4,6
KJV

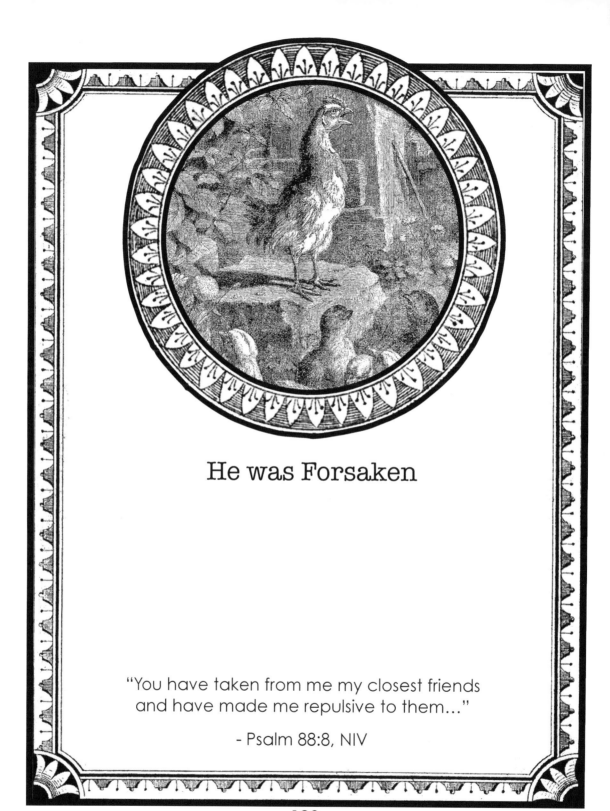

He was Forsaken

"You have taken from me my closest friends
and have made me repulsive to them…"

- Psalm 88:8, NIV

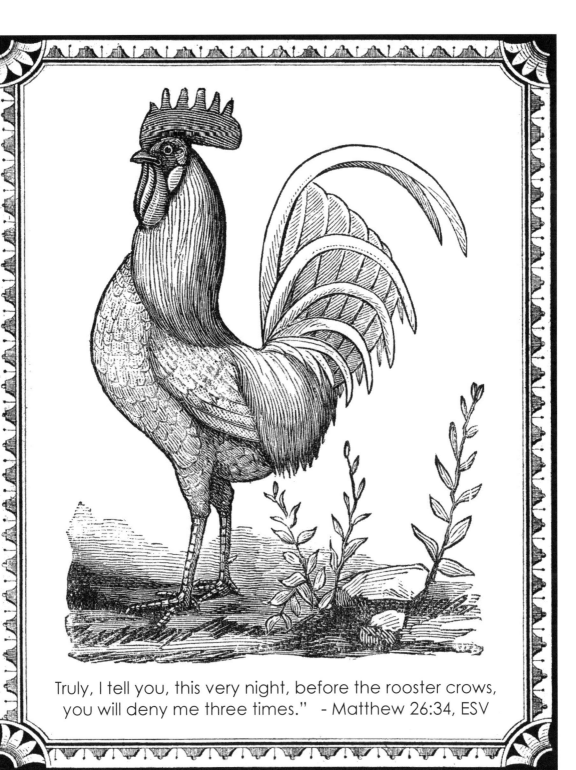

Truly, I tell you, this very night, before the rooster crows,
you will deny me three times." - Matthew 26:34, ESV

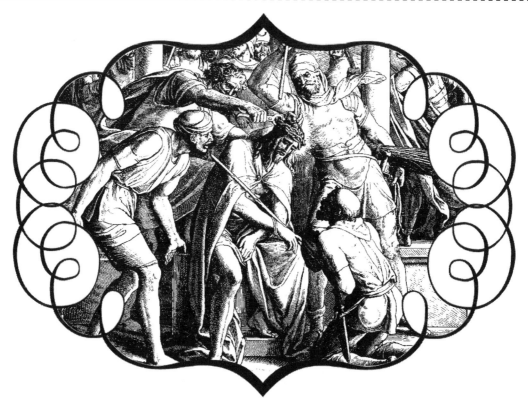

Abused and Humiliated

"The soldiers also mocked Him, coming up to Him,
offering Him sour wine, and saying,
'If You are the King of the Jews, save Yourself!'"

- Luke 23:36-37, NIV

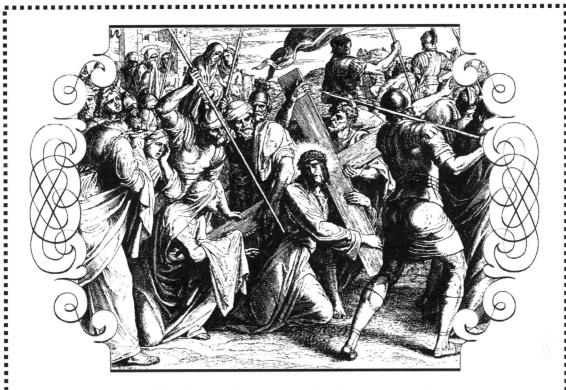

Ridiculed and Scorned

"And even the rulers were sneering at Him, saying,
'He saved others; let Him save Himself
if this is the Christ of God, His Chosen One.'"

- Luke 23:35, NIV

Crucified

"They put a purple robe on Him, then twisted together a crown of thorns and set it on Him."

- Mark 15:17, NIV

...For Me

"There they nailed Him to the cross.
Two others were crucified with Him,
one on either side,
with Jesus between them."

- John 19:18, NLT

"Remember, Lord, how your servant has been mocked,
how I bear in my heart the taunts of all the nations,
the taunts with which your enemies, Lord, have mocked,
with which they have mocked every step of your anointed one."

- Psalm 89:50-51, NIV

At
Calvary

At the Old Rugged Cross

- John 19:1-6

- John 19:16-19

- Luke 23:32-34

- Mark 15:29-34

- John 19:25-27

- Matthew 27:50-54

"For the message of the cross is foolishness to those who are perishing, but to us who are being saved it is the power of God."
- 1 Corinthians 1:18, NIV

Stripped of His Robes

"They divided
His clothes
by casting lots."

- Luke 23:24b, NIV

Nailed
to a
Tree

"Jesus said, 'Father, forgive them, for they know not what they do.'"

- Luke 23:34a, KJV

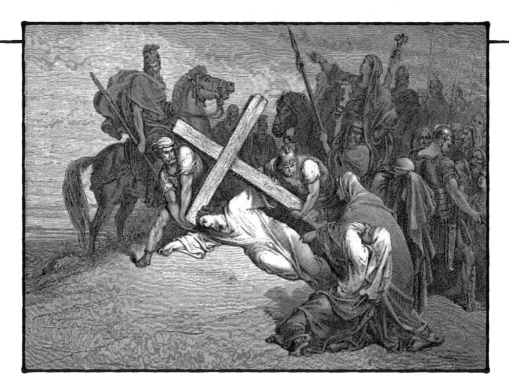

Man of Sorrows

"A great number of the people followed Him,
among them women who were mourning and wailing for Him.
But Jesus turned to them and said, 'Daughters of Jerusalem,
do not weep for Me, but weep for yourselves & for your children.'"

- Luke 23:27-28, NET

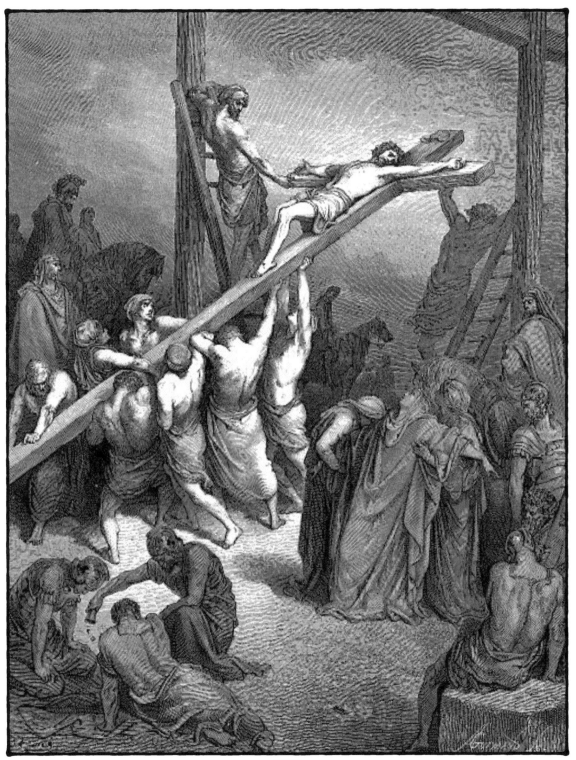

Christ was Lifted Up

"And when I am lifted up from the earth,
I will draw everyone to Myself."

- John 12:32, NLT

He Died for Sinners

"But God demonstrates His own love for us in this:
While we were still sinners, Christ died for us."

- Romans 5:8, NIV

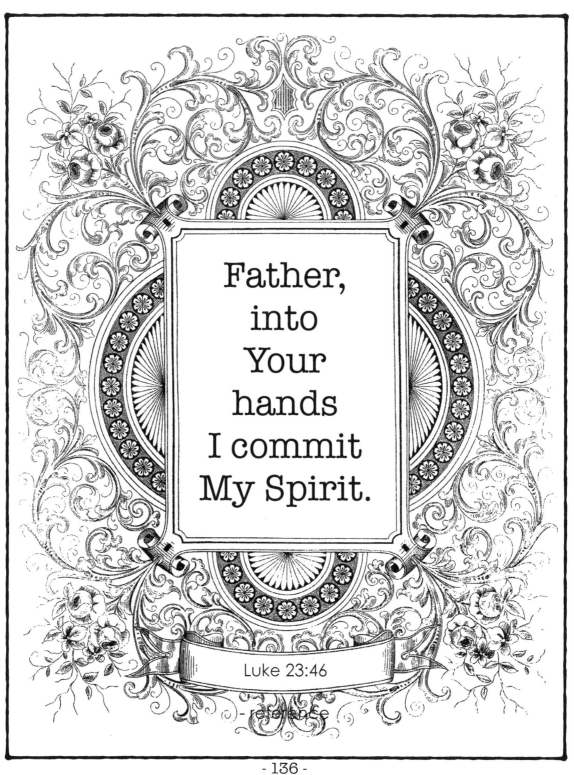

Father,
into
Your
hands
I commit
My Spirit.

Luke 23:46

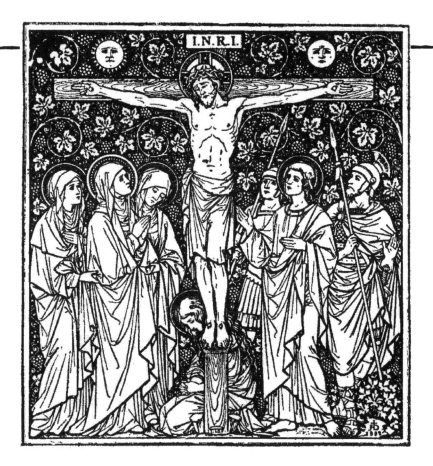

It is finished!

"I have brought You glory on earth
by finishing the work You gave me to do."

- John 17:4, NIV

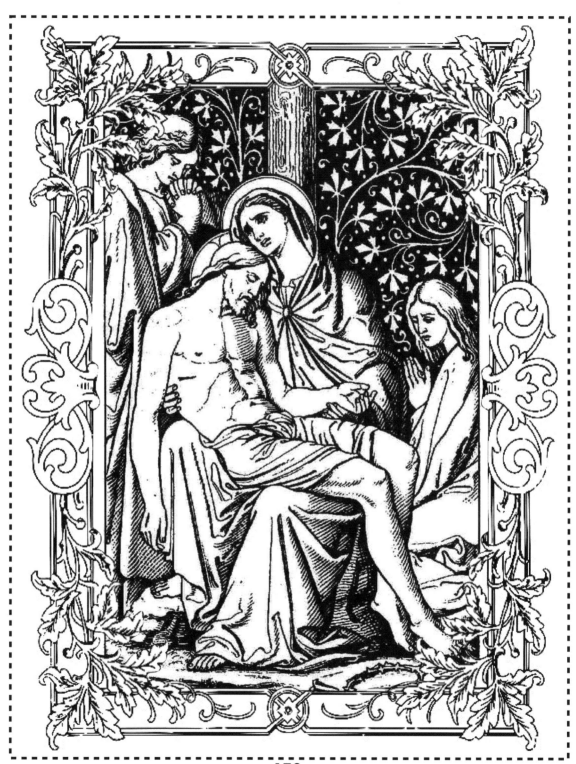

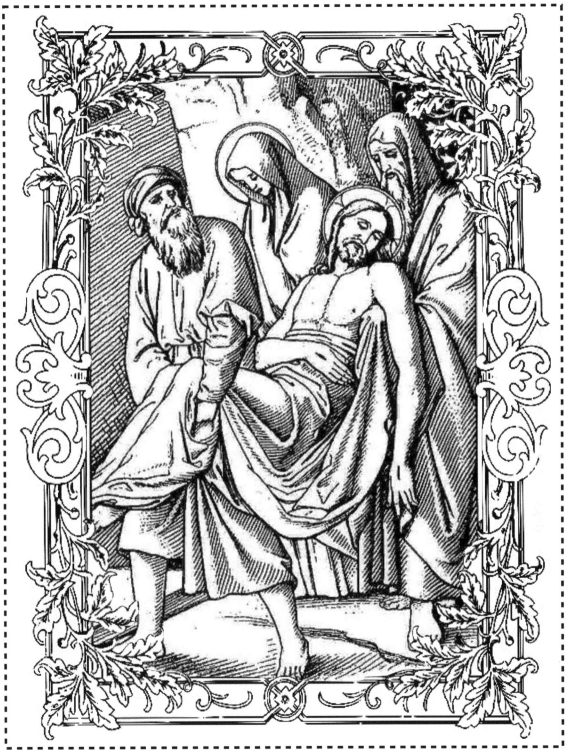

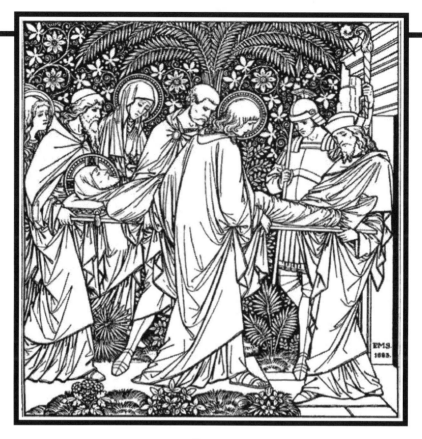

Dead & Buried

"So they took the body of Jesus and bound it in linen wrappings with the spices, as is the burial custom of the Jews."

- John 19:40, NASB

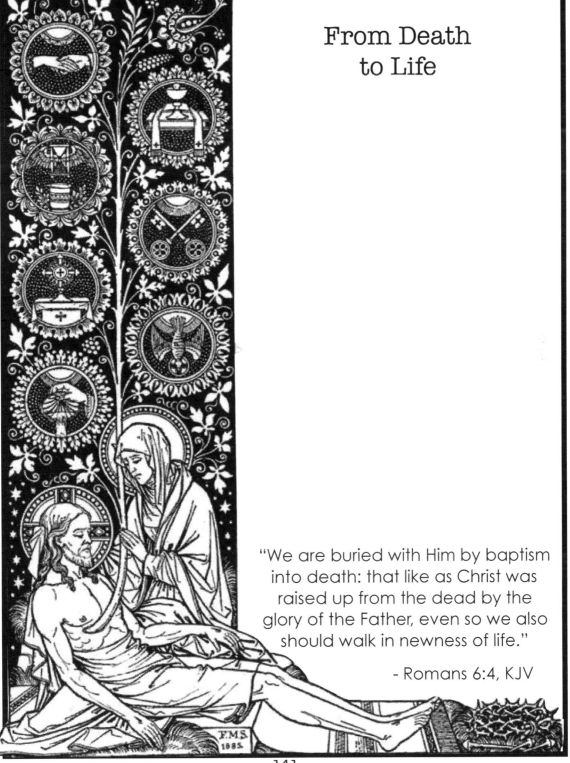

From Death
to Life

"We are buried with Him by baptism into death: that like as Christ was raised up from the dead by the glory of the Father, even so we also should walk in newness of life."

- Romans 6:4, KJV

"May I never boast except in the cross of our Lord Jesus Christ,
through which the world has been crucified to me,
and I to the world."

- Galatians 6:14, NIV

He Is Risen
Indeed

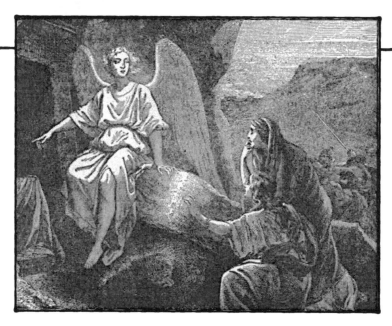

Going to the Tomb

"There was a violent earthquake, for an angel of the Lord
came down from heaven and, going to the tomb,
rolled back the stone and sat on it."

- Matthew 28:2, NIV

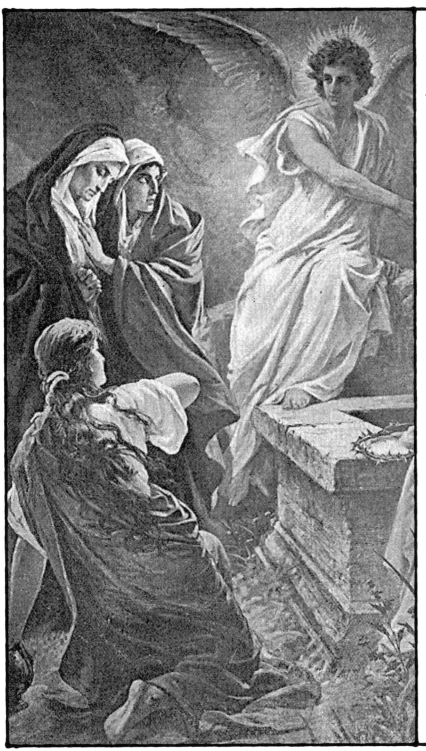

"The angel said to the women, 'Do not be afraid, for I know that you are looking for Jesus, who was crucified. He is not here; He has risen, just as He said. Come & see the place where He lay.'"

- Matthew 28:5-6
NIV

An Empty Tomb

"They found the stone rolled away
...but when they entered, they did
not find the body of the Lord Jesus."

- Luke 24:2-3, NIV

He is
Not Here

"Why seek ye the living
among the dead?"

- Luke 24:5, KJV

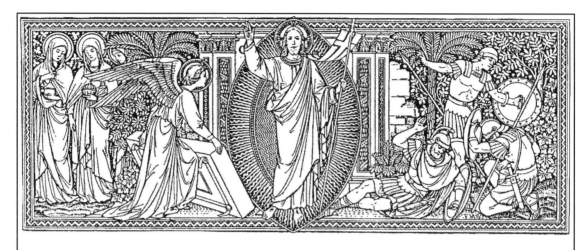

He is Risen

"Remember how He spoke to you while He was still in Galilee, saying that the Son of Man must be delivered into the hands of sinful men, and be crucified, and the third day rise again."

- Luke 24:6, NASB

Lifted up
was He to die;
"IT IS FINISHED"

was His cry;
Now in Heav'n
exalted high.

HALLELUJAH!

What a Savior!

- Philip P. Bliss

A Frightful Encounter

"[The angel's] appearance was like lightning, and
his clothes were white as snow. The guards were so afraid of him
that they shook and became like dead men."

- Matthew 28:3-4, NIV

A Marvelous Resurrection

"But Peter got up and ran to the tomb; stooping and looking in,
he saw the linen wrappings only; and he went away
to his home, marveling at what had happened."

- Luke 24:12, NASB

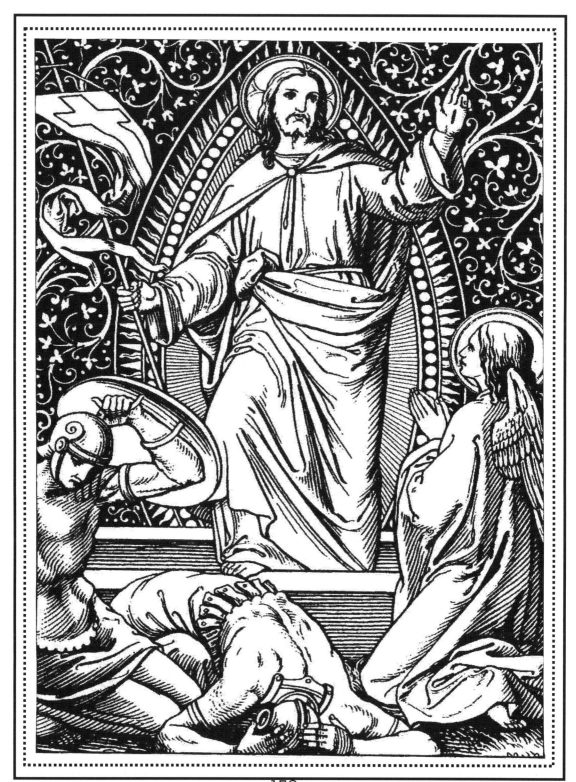

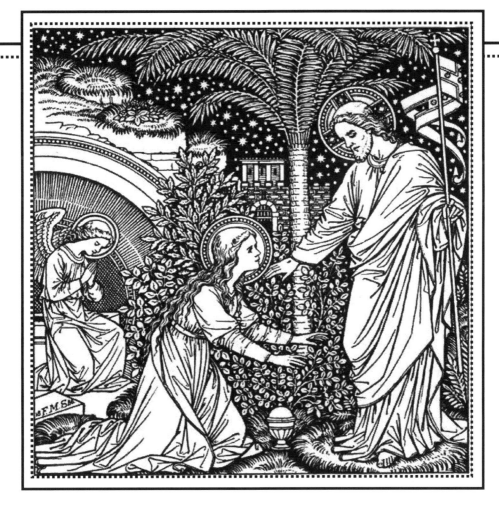

Why Are You Weeping?

"Jesus said to her, "Woman, why are you weeping?
Whom are you seeking?" Supposing Him to be the gardener,
she said to Him, "Sir, if you have carried Him away,
tell me where you have laid Him, and I will take Him away."

- John 20:15, NET

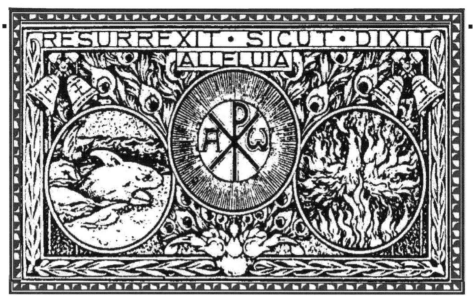

Remember His Words

"This is a wicked generation. It asks for a sign,
but none will be given it except the sign of Jonah."

- Luke 11:29, NIV

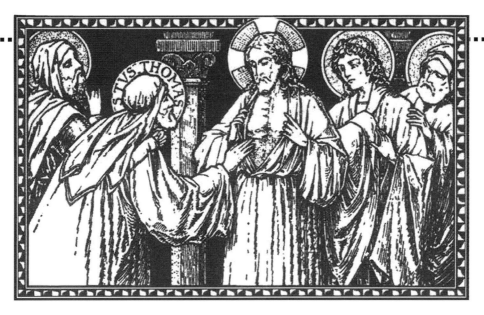

See His Scars

"Then He said to Thomas, 'Put your finger here;
see My hands. Reach out your hand and put it into My side.
Stop doubting and believe.'"

- John 20:27, NIV

"By His power God raised the Lord from the dead,
and He will raise us also."

- 1 Corinthians 6:14, NIV

More Than Conquerors

Triumphantly Victorious

"Nay, in all these things we are more than conquerors through Him that loved us."

- Romans 8:37, KJV

Overcoming the World

"For whatever is born of God
overcomes the world; and this is the victory
that has overcome the world—our faith."

- 1 John 5:4, NASB

But God demonstrates His own love for us in this: while we were yet sinners, Christ died for us. Romans 5:8

It is for

FREEDOM

that

CHRIST

has set us

FREE

Galatians 5:1

Jesus wore this crown →

so that we could gain these crowns:

A CROWN OF LIFE

"Blessed is the one who perseveres under trial because, having stood the test, that person will receive the crown of life that the Lord has promised to those who love him." – James 1:12

"Be faithful until death, and I will give you the crown of life." – Revelation 2:10

A CROWN OF RIGHTEOUSNESS

"Now there is in store for me the crown of righteousness, which the Lord, the righteous Judge, will award to me on that day—and not only to me, but also to all who have longed for his appearing." – 2 Timothy 4:8

A CROWN OF GLORY

"And when the Chief Shepherd appears, you will receive the crown of glory that will never fade away." – 1 Peter 5:4

"[Wisdom] will give you a garland to grace your head and present you with a glorious crown." – Proverbs 4:9

A CROWN OF KNOWLEDGE

"The simple inherit folly, but the prudent are crowned with knowledge."
 - Proverbs 14:18

A CROWN OF VICTORY

"For the LORD takes delight in his people; he crowns the humble with victory."
 - Psalm 149:4

A CROWN OF LOVE

"[God] redeems your life from the pit and crowns you with love and compassion."
 - Psalm 103:4

A CROWN OF JOY

"Those the LORD has rescued will return. They will enter Zion with singing; everlasting joy will crown their heads. Gladness and joy will overtake them, and sorrow and sighing will flee away." - Isaiah 51:11

AN ETERNAL CROWN

"Everyone who competes in the games goes into strict training. They do it to get a crown that will not last, but we do it to get a crown that will last forever."
 - 1 Corinthians 9:25

Thanks Be
to God!

"He gives us the victory
through our Lord
Jesus Christ."

- 1 Cor. 15:57, NIV

Christ has triumphed
o'er the grave!

CONQUERED DEATH!

His blood He gave;
Set me free,
who was sin's slave.

HALLELUJAH!

What a Savior!

- Jennifer Flanders

Free from Lawlessness

"He gave Himself for us
to set us free from every kind of lawlessness
& to purify for Himself a people who are truly His,
who are eager to do good."

-Titus 2:14, NET

Abounding in Good Works

"Therefore, my beloved brothers, be steadfast,
immovable, always abounding
in the work of the Lord, knowing that in the Lord
your labor is not in vain."

- 1 Corinthians 15:58, ESV

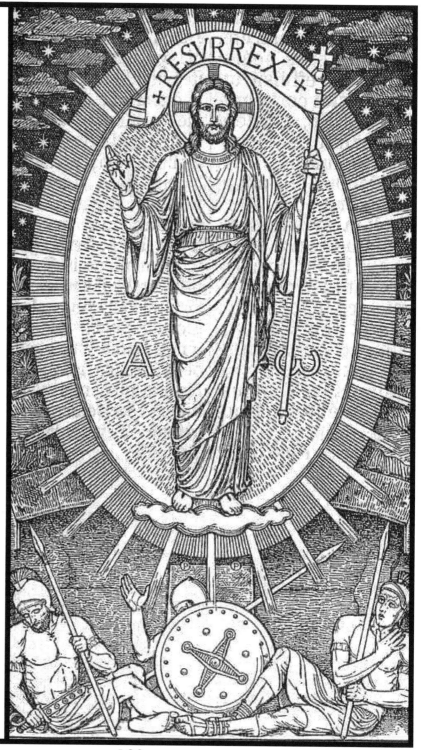

"I want to
know Christ
and
the power
of His
resurrection
and the
fellowship
of His
sufferings,
being
conformed
to Him
in His
death..."

- Philippians 3:10
Berean Study Bible

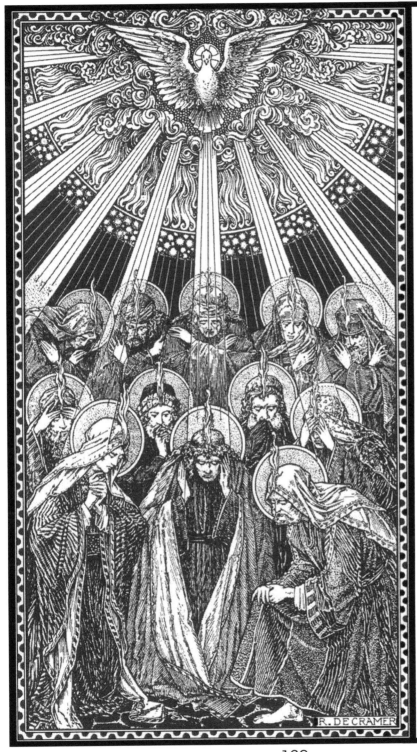

"But you
will receive
power
when the
Holy Spirit
comes upon
you; & you
will be my
witnesses in
Jerusalem,
& in all
Judea &
Samaria, &
to the ends
of the earth."

- Acts 1:8
NIV

"For He has rescued us from the dominion of darkness
and brought us into the kingdom of the Son He loves,"

- Colossians 1:13, NIV

Preparing a Place

As a Bird Builds Her Nest

"Even the sparrow finds a home,
and the swallow builds her nest
and raises her young at a place
near your altar,
O LORD of Heaven's Armies...."

- Psalm 84:3, NLT

So Jesus Prepares a Home for Us

"…my King and my God! What joy for those
who can live in your house, always singing your praises."

- Psalm 84:4, NLT

Mansions
He's prepared for me;
where

I'LL LIVE ETERNALLY.

Evermore
my praise shall be,

HALLELUJAH!

What a Savior!

- Jennifer Flanders

Anyone who listens
to My teaching and follows it is wise,
like a person who builds a house
on solid rock.

- Matthew 7:24, NLT

a heavenly home

"One thing I ask from the LORD, this only do I seek:
that I may dwell in the house of the LORD all the days of my life,
to gaze on the beauty of the LORD & to seek Him in His temple."

- Psalm 27:4, NIV

my house shall be called a house of prayer.

mark 11:17

Enter His Gates with Thanksgiving

"Lift up your heads, O gates! And lift them up, O ancient doors, that the King of glory may come in! Who is this King of glory? The LORD of hosts, He is the King of glory."

- Psalm 24:9-10, NASB

Come into His Courts with Praise

"Better is one day in Your courts than a thousand elsewhere;
I would rather be a doorkeeper in the house of my God
than dwell in the tents of the wicked."

- Psalm 84:10, NIV

Surely Goodness
and Mercy shall
follow me all the Days
of my Life:
and I will dwell in
the House of
the Lord
Forever.

- Psalm 23:6, KJV

Feasting at His Banquet Table

"And people will come from east and west,
and from north and south,
and recline at table in the kingdom of God."

- Luke 13:29, ESV

"Righteousness and justice are the foundation of Your throne;
love and faithfulness go before You."

- Psalm 89:14, NIV

Coming
Again

Together with the Lord

"If I go and prepare a place for you,
I will come again & receive you to Myself,
that where I am, there you may be also."

- John 14:3, NASB

Behold,
I tell you a mystery;
we will not all sleep,
but we will all be changed,
in a moment,
in the twinkling of an eye,
at the last trumpet;
for the trumpet will sound,
and the dead
will be raised imperishable,
and we will be changed.
For this perishable must
put on the imperishable,
and this mortal must
put on immortality.

- 1 Corinthians 15:51-52, NASB

Thy King Cometh

"Arise, shine; for thy light is come,
and the glory of the LORD is risen upon thee."

- Isaiah 60:1, KJV

An Everlasting Light

"He rescued us from the domain of darkness,
and transferred us to the kingdom of His beloved Son."

- Colossians 1:13, NASB

Watching & Waiting

"Take heed, keep on the alert; for you do not know when the appointed time will come."

- Mark 13:33, NASB

Looking Above

Acts
1:7-11

- Mark
13:24-37

- Romans
14:8-12

- 1 Thess.
4:15-17

Every Eye Shall See

"Behold, He is coming with the clouds,
and every eye will see Him, even those who pierced Him;
and all the tribes of the earth will mourn over Him. So it is to be.
Amen."

- Revelation 1:7, NASB

Every Knee Shall Bow

Isaiah 45:23

"So that at the name of Jesus every knee will bow,
of those who are in heaven & on earth & under the earth,
and that every tongue will confess that Jesus Christ is Lord,
to the glory of God the Father."

- Philippians 2:9-11, NASB

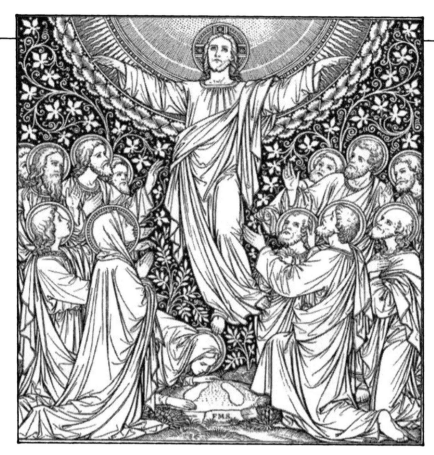

Christ Shall Come with Trumpet Sound

"For the Lord Himself will descend from heaven with a shout,
with the voice of the archangel and with the trumpet of God,
and the dead in Christ will rise first."

- 1 Thessalonians 4:16, NASB

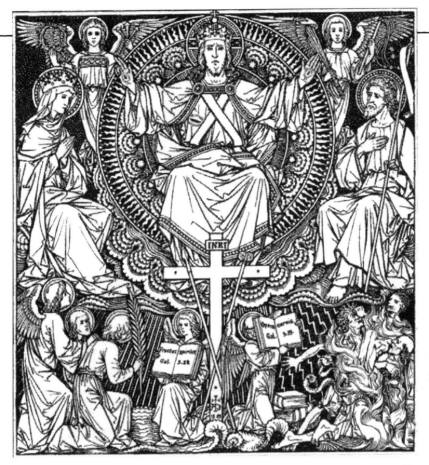

Oh, May I Then in Him be Found

"Then we who are alive and remain will be caught up together
with them in the clouds to meet the Lord in the air,
and so we shall always be with the Lord."

- 1 Thessalonians 4:17, NASB

"The time is fulfilled, and the kingdom of God is at hand;
repent and believe in the gospel."

- Mark 1:15, NASB

The Hope of Glory

"...live sensibly,

righteously and godly

in the present age, looking for the

BLESSED HOPE

and the appearing

of the glory

of our great God and Savior,

Christ Jesus."

Titus 2:12-13
NASB

Die to Self

"And He was saying to them all,
'If anyone wishes to come after Me, he must deny himself,
and take up his cross daily and follow Me.'"

- Luke 9:23, NASB

Live *for* God

"Even so consider yourselves to be dead to sin,
but alive to God in Christ Jesus."

- Romans 6:11, NASB

The Church
is the
Bride of Christ

"Let us rejoice and be glad and give Him glory!
For the wedding of the Lamb has come,
and His bride has made herself ready. "

- Revelation 19:7, NIV

Husbands, love your wives as Christ loved the church and gave Himself up for her to make her holy, cleansing her by the washing with water through the word, and to present her to Him- self as a radiant church without stain or wrinkle or any other blemish, but holy and and blameless. So in this same way, husbands ought to love their wives as their own bodies. He who loves his wife loves himself. self. After all, ever no one their hated but they own body, care for feed & just as their body, the Christ does church..."

- Ephesians 5: 25-29

New Life in Christ

- Romans 6:3-4

- Titus 3:5

- Colossians 3:1-3

- 2 Corinthians 5:17

- 1 Peter 1:3

To be continued...

"Jesus did many other things as well. If every one of them were written down, I suppose that even the whole world would not have room for the books that would be written."

- John 21:25

When He comes,
our

GLORIOUS KING

all His ransomed
home to bring;
then anew His song

WE'LL SING:
HALLELUJAH!

What a Savior!

- Philip P. Bliss

"And so we will be with the Lord forever.
Therefore encourage one another with these words."

- 1 Thessalonians 4:17-18, NIV

One Last Word from the Author:

I hope you've enjoyed working your way through this book as much as I enjoyed creating it. I've been making and keeping personal journals and sketchbooks—and lots and lots of scrapbooks—for over forty years now, so creating this series for others to use has been a lot of fun. I made the books with my own children in mind, as they definitely take after their mom when it comes to writing and drawing, but I thought perhaps other people (young or old) might like them, as well.

If that describes you, I would love for you to leave a positive review on Amazon, so others can get an idea of what the journal is like. Additional volumes are available—including journals for boys, moms, and wives—on a variety of topics. If you have any questions or suggestions, feel free to contact me through my family's website, www.flandersfamily.info. Although I read every message I receive, time constraints do not allow me to respond personally to most of them. My twelve kids and nine grandkids (so far!) keep me much too busy for that, at least in this season of my life.

Check out my other books:

25 Ways to Communicate Respect to Your Husband:
A Handbook for Wives

Balance:
The Art of Minding What Matters Most

Color the Word:
The Bread of Life

Color the Word:
Clothed in His Righteousness

Color the Word:
The Fruit of the Spirit

Color the Word:
My Heart, Thy Home

Color the Word:
The Walk of Faith

Get Up & Go:
Fun Ideas for Getting Fit as a Family

Glad Tidings:
The First 25 Years of Flanders Family Christmas Letters

Love Your Husband/Love Yourself:
Embracing God's Purpose for Passion in Marriage

Sit Down & Eat:
Fun Ideas for Making Mealtime Memorable

Don't miss the other volumes in this series:

All Things Bright & Beautiful

a devotional journal for nature lovers
Jennifer Flanders

Be Still, My Soul

a devotional journal for boys
Jennifer Flanders

Bread of Heaven

a devotional journal for culinary artists
Jennifer Flanders

Count Your Blessings

a devotional journal for thanksgiving
Jennifer Flanders

God Bless America

a devotional journal for patriots
Jennifer Flanders

How Do I Love Thee?

a devotional journal for wives
Jennifer Flanders

Joy to the World

a devotional journal for advent
Jennifer Flanders

Moment by Moment

a devotional journal for girls
Jennifer Flanders

Sweet Child of Mine

a devotional journal for moms
Jennifer Flanders

Answers to Passion Week Quiz
"Who Said What?" on page 91:

1-g, 2-s, 3-o, 4-d, 5-t, 6-h, 7-l, 8-i, 9-f, 10-k, 11-j,
12-p, 13-r, 14-n, 15-a, 16-c, 17-e, 18-m, 19-b, 20-q

Manufactured by Amazon.ca
Bolton, ON

33306849R00122